Two
Different
Angles

Daljit Khankhana

iUniverse, Inc.
New York Bloomington

Two Different Angles

iUniverse books may be ordered through booksellers or by contacting:

iUniverse
1663 Liberty Drive
Bloomington, IN 47403
www.iuniverse.com
1-800-Authors (1-800-288-4677)

ISBN: 978-1-4401-5421-8 (pbk)
ISBN: 978-1-4401-5422-5 (ebk)

Printed in the United States of America

iUniverse rev. date: 6/17/2009

Dedications

I would like to present this book:;
Those were raped or killed innocently
By,
The intellectuals
And never brought for Justice
In any Human civil Rights Court.

Contents

A Matter of Learning:

How can a person concentrate on such particular subjects those are lead-ing a person to his glory and challenging to the welfare for mankind? Concentration is an aspect to target on dedications that is appealing to our hearts those are struggling for positive growth.

Success isn't only a process of encouragement also concentration is a major part of any role that we have taken in our deeds although almost it is accountable in our daily practice of any kind of choice that a person has chosen, selected or nominated by his crafts.

Those people who targeting on their sources that is energy of time and the activities for a human body that accelerate it to produce something. Very few know that they are conscious for productivity or its consequences.

That's why it differs in two main categories.

Physical progress and mental development.

The intellectual people have to say, the value of time and energy, they tried to prefer not to waste it.

But most un-intellectual, they knew everything but failed to apply such

applications those they have identified as options. A person waste his time through mistakes and never learns a lesson that he deserves to learn and waste their entire life in thinking or struggle to reassure that what was his role in the failure process?

They always are worrying to investigate on others and their achievements. When they have something to say they use them as a key success of their role because they motivated it for their incoming earnings.

Concentration provides restoration for problems to develop sensitivity. Until a person isn't a genius that means he/she not sincere for a cause he never dares for experiments.

We all have time that is known a life. A person feels pain in that process when he/she is in a walking mood to high routes and having no support sticks. Then he most decides to change his journey.

He decides to use others for his travelling. He differs on that time when he feels he is physically not fit as a labourer that works hard for somebody for little earnings. Then he prepares mind for a wheel fortune. He uses wood sticks for it and replaced it on a metal sheet with a rubber or a colour pen for further options that he would like to apply in future.

Only Concentration works behind any issue. When a player concentrates on his game, he becomes a hero in his game.

Poetry is only a theme of concentration. When a poet concentrates on an idea, he develops images. He compares his thoughts with natural symbols for its beauty. It is an art to compile words for themes.

If a poet compiles a heart-appealing poem, it is a sensitivity of his/her thinking that collects the choiceable ideas.

There are few people when they think, they feel headache because they haven't such technique of concentration to utilise their ideas into a shape.

A matter is a matter. A person can use it for a challenge or entertainment. Few people's mind are skilled to abuse others but sometimes someone's abuse also guides a person to search his way for success. As a father abuses his baby for change or a coach to a player or a teacher to a student etc are not jealous.

I never thought one day I shall become a poet in English literature because I were born in the northern part of India in west Punjab where my tongue was only Punjabi.

I wrote in Punjabi on my initial target only to participate on youth festivals in college competitions. Although Punjabi was also not my

thoroughly study subject, I read few poems on religious gatherings in my childhood.

I never learned the techniques of writing to become a professional poet as others do to copying the ideas or they call it mastering on skills.

I followed only experience or knowledge of my spirit that I gained in my working fields.

A Good Reader is a best critique that provides guidelines to a writer. That only I admit personally because without a reader as critique a poet or a writer can't improve his image of writings.

When I published my first short story book, 'Sihkade Patthar' Smouldering Stones in 1983, it was very popular, I collected very different views, and actually, that book was a need of time.

I never learned to write a short story or never read others deeply on a particular subject that write stories but readers taught me about the techniques but at present I admit that reading is a main aspect for writing but I am not able to establish field without a good reader it may only has a good writer.

The fact is that I don't want to copy of anyone in my writings. I tried always not to steal ideas but techniques may be the same as others. It was my wish to write different with my own style to establish new techniques that I am following with my concerns.

The reader will accept my writings or not, I never touched this issue but I am writing non-stop without any interruption under my eagerly influences.

Two different Angles is the fourth creation in English Poetry World also there has been published three of poetry books with these titles, A Symbol of Unity, A Chapter of life and A fresh touch.

At present another two titles are concentrating for its completion of manuscripts.

I have only spirit of writing that has awakening me to force to write.

I am always searching for a pen or paper because I have no special time for writing. I write when an idea comes to me. I never think for imaginatively to write.

I write when writings forced me to write. I am unable to draw a sketch for my writings.

What I wrote, it is very natural and enjoyable myself. It may have a joke if it is sufficient to laugh. I also like to enjoy myself because I don't want to waste my time in jealousy. When I walked, I share my happiness

with others those aren't known to me I can't call them strangers. They are my prospective happiness. My writings are for everyone's pleasure. I hope you shall enjoy it. Amen

Daljit Bahadur Singh (Khankhana)
5 Albion Avenue, Willenhall
West Midlands. United Kingdom.
WV13 1NW

Laugh is Free

If I do something wrong, don't laugh at me,
No argument on my freedom I know laugh is free.
If someone is injured and crying for pain,
Why is laugh necessary he needs to use brain?

You can choose that laugh isn't a good matter,
You need a place to enjoy that's only better.
If you will seed the nails then who will walk free,
Why does a person ignores it is my worry?

If everyone publically throws rubbish, what will be a face?
If animal will astonish then what is a human grace?
A person only can serve that can do lot better?
Nobody can serve better if serving a person is cheater.

Roots are going downward and leaves upward,
A person can walk forward as he can go backward.
He is getting old and becoming for a child cruel,
He is selfish and greedy that playing everywhere foul.

Two Different Angles

Different problems,
or
Two different angles.
Positive,
or
negative.
Backward,
or
forward.
Approachable,
or
 Non-approachable.
Cooperative,
or
Non-cooperative.
Awared,
or
Unwared.
Awakened,
or
Un-awakened.
But
That is for a subject of life.
Enlightened,
or
Non-enlightened.
Strugglefull or painful
A path of Death,
Darkness
Fear or danger,
An achievable or unachievable,
A part of dedications,
That
We failed or achieved it.
At last,
A little satisfaction,
One further step
I may have sound sleep.

A Power of Change

When I stood up,
At the top of a mountain,
Air thirsted me,
My ears whistled upon it.

My eyes backcrossed through the sky,
A white ball,
On my left,
And,
A golden burning ball
On my front appeared.

The dark clouds were floating,
And
Without any destination,
Only flying,
Left to right or right to left,
Below and above,
Sometimes disappearing,
Out of my sights.

But
At the top of Mountains and rivers,
Trees and Birds,
Into the Sky,
Under the Moon or Sun,
Not on each planet,
Only on earth,
That can sing or dance,
Or whistle into my ears

A Voice appears as echo,
A Person can listen through air,
A person can live in Air,
A person can see through Air,
Air isn't only air,
Air is actual life,
A Power for change,
A leading role for life.

Across the Wall

A Light was burning,
Unfolded the table it was open,
A bundle of mysteries,
A book was unread.

The words were hanged,
A long legged spider,
In the light,
Knitted a web,
And safety catches,
Eyes were unable to watch,
Brain was dusty to see,
The mind of an insect.

Darkness was cool,
Peace was on the sleeping bed.
But
A stormy subject,
And a boat of mind,
Never read the time.
Ignorable as it usual.
The height of the tides,
Loneliness, A common place
Where anybody can enter.

My breath was feeling rust,
Light was unable,
To flash that was across the wall,
Darkness has wearing a black suite.
Night was moving,
Backward to forward,
To reflect a new image of life,
But
Darkness still was holding a place,
Under the feet of a wall,
A golden ball was promptly fierce.

My shy

I have no such dream that can fly.
I have no such matter on me, which can rely.

If food is a matter who cares for it,
If wearing isn't better who pays for it,
If you understand you 'r better gain it and try.

Your blames have flames anybody can do,
Those didn't have concern they are also through,
You feel nervous also me, we all have a cry?

If my master isn't happy, how can I gain?
If nobody will change a nappy a cry how should lain?
A child understands love, that's me shy.

Why is a child innocent if he has love affection?
Why does he understand only love is a best direction?
You blame me I 'm poor but my love isn't lie.

The Descriptions

You always think,
I am a child,
I need more training,
To sell best a product.

To understand,
The nature of your product,
But
When you put an idea,
In my human computer,
And tried to upgrade it,
To match the qualities.
You were astonished,
To read my abilities.
Where a motto was unread,
'Honesty is a best policy'.
Hard working and honest..

The descriptions of a human nature.
The efficiency for an average living,
You open various different files,
To alter barriers,
To build new options,
To accelerate your image
To build a new ghost hut,.
That can suck my generation, and me
Easily and smoothly.

You were compelled to say,
I am an able worker,
I am no longer untrained.
You can trust me,
Because I were profitable.
I always used me,
To exploit others,
To sell your product,
That was only my responsibility.

A House Wife

Naturally, a human has anger and loving nature,
Sometimes, abusive behaviour seems discarded furniture.
Argument is normal in our living life,
When two person lives as a partner or wife.

After ten years relationship, when he has blamed,
He only runs home, she is home carer, shamed.
When she left him and went to her mother,
House was cleaned and has decorative feather.

No white rings, scratches, burns and dents,
No grease marks, chips and ink on paint.
Cats, dogs and birds she has knitted by her hands,
Cutting, stitching and finishing she has skill that is grand.

Cross over and jardinière net curtains she made,
I am sorry about simple and dropped the nets afraid.
I never seen so much dirt in her presence in kitchen,
I ran after her to bring back a quality motion.

Why do I expect?

Would you like to pay me something?
Would you like to say something?
Why do you expect from me?
And why do I expect from you?

What do you know about me?
And what do I know about you?
Why do you mind if I want to share?
And why do I mind if you like me care?

What is your relation to me?
And why I would like to know?
Why do you work so fast?
And why do I work slowly in snow?

Why do you have a different taste?
And why do I like you almost?
Yesterday, when you were a child,
I were hungry you enjoyed your toast.

You and I were play together,
We never bother what was the weather.
Today when I realized my hunger,
Why did you abuse my mother?

You never asked me a question,
When I were a child not having a fashion,
Why do you love a particular colour?
What is a caste not a race of my nation?

We play together when childhood was faith,
You believe in religion, tradition is a myth.
You understand me what opinion differs,
I like to live together but you never bother.

Today is a God Gift and tomorrow is hope.
Happiness and sorrows are life to tight time rope.
A person can rise up or commit suicide for it,
Pace counts ever if walking is on slope.

Mind of Nature

When smoke was rounding in a cycle,
Sunrays were developing a miracle.
Carbondioxide and oxygen got its birth,
A first drop of water touched the Planet.
On his first day.

When water started to vaporise,
Gases and chemicals produced a seed,
Steam opened mind of nature,
Sun was smiling on a new creature.
On his second day.

When smoke converted into drops,
Rain touched the burning heart of soil,
Nature took time to balance planets.
Time removed all were playing a foul.
On his third day.

When days and Nights got pregnancy,
Time became a first child of nature.
Seed delivered hearts to grow,
After Rain, frogs appeared as mature
On his forth day.

The Earth became a World,
Trees, insects, animals and human,
Got their birth, as well as,
Time provides them colours.
On his fifth day.

What and When
A person delights,
When he feels astonishing to fight
Happiness and sorrows grows in calm.
On his sixth day.

A person weeps,
When he gets nervous.
And he realises himself,
How sad he is?
On his seventh day.

When he understands differences,
He plans for better living,
The values and resources,
Draws a path for him.
On his eighth day.

Joy and happiness he aims,
Success and luxury he claims,
His motive is living for pleasure,
Target is only a rising measure.
On his ninth day.

He feels sick when he fell over,
He lost courage to power grower,
He lives with his memories and blames others,
He realises always but never bother.
On his tenth day.

Life is turning,
In a fortune wheel,
But Circumstances
Cycle in a round beam.
On his eleventh day.

I am happy why you not,
If you failed, let's go to restart,
We are dying a message is true,
Don't blame me, everything will be through.
On his twelfth day.

Process of Growth

Nature provides equal opportunity to grow,
Plants, animals, birds and human's growth is slow,
Heat, cold, air and soil has fertilisation for food,
Rain helps everyone for growth that is fruit or wood.

A Lion is non-vegetarian; his food is only meat,
He has a terror for animals and a human defeat.
Elephant is vegetarian greenery is his food,
A Man shares his burden when he has a big load.

He uses Lion and elephant to train for a circus,
He seeks only enjoyment when he feels he is fuss.
Elephants win the battles for a man,
He fights against an enemy when he is in train.

Animals eat animals, too birds and insects,
They also eat grain and fruit for their pickets.
A Fish eats only fish but everyone eats fish,
Only a shark has different attack for his tasty dish.

A human eats food, fruit and meat for energy,
He takes vitamins and minerals for heat clergy.
Iron keeps us warm helps blood to maintain strength,
Vegetables and fruit help a person for a term length.

Obesity, blood pressure, Angina and heart attack,
Garlic, Ginger, onion comes in a kitchen back.
Blood cholesterol, clouts and arthritis,
When he feels sick he opens, a vegetable slights.

A person learns about his food when he is weak,
He learns to cook a soup, carrot, mushroom and leak.
Celery, lettuce, cucumber and tomatoes he eats fresh,
Cauliflower, peas, potatoes and broccoli, he boils dish.

Cheese, Milk, sugar and salt, make a bread tasty,
Chocolate, cherry and flour make a pleasure pastry,
Chips and crisps, young food, fry, grill and cooking,
Chutney, sauce and vinegar he orders for a tasty booking,

Air, water and food, a natural system for existence,
What is right to eat or wrong a man seeks balance?
A Man likes to enjoy life, healthy body and mind,
Younger generation and memories he lives behind.

Her Choice

Beauty is her choice she loves beauty,
Matching is her choice she loves fruity.
Make up, hairstyle and lovely dressings,
Eyebrows, eyelids, lips and cheeks restrings.

Earrings, necklaces, rings and bangles,
A purse, stockings, a skirt and sandals,
How does she look like when she walk's her step?
A mirror reflects on her eyes when she likes trip.

She walks with open eyes to see a handsome,
A lovely and charming lad who offers her rum.
Watches her eyes and trying to touch her heart,
He loves to pinpoint when he plays dart.

What do you think about this lovely evening?
Wind is blowing cool body is catching a sting.
Let's go to dance and we can eat little later,
They had gone together to pay tips to a waiter.

Sensitivity of Nature

When a person approached investigatively,
He chases his relations suspensively,
He finds clue and works dramatically,
Suspection always works progressively.

Confirmation of belief confirms sensitivity,
Growth brings a change to work relatively,
Hunger is seeking growth for productively,
A limit of growth confirms value qualitatively.

When population has highly density,
Unemployment works offensively,
Poverty grows increasing growth dramatically.
Disaster comes to balance creatively.

Everything is naturally fast and slow,
A person has no patience to balance a flow,
Air can't across a cycle of gravity,
Sun has different heat to rate creativity.

A Liquid Iron

When a man first made sword,
How will it be reckoning him?
He was a scientist or
He was a top scholar.

How did he find a liquid Iron?
And tested it for cooling down,
With Fire and water but no ash remains left,
He will be astonishing to see a hard stump.

He will be delighted to find it,
Iron melts with fire and
It gets harder with water,
And it can be polished to shine.

Human knowledge is as Iron,
If we use them, it expands as Iron,
If we don't use it remains as a solid iron,
We can gain experience to use our knowledge.

A Nice Trim

When a person is responsible,
He takes his worries.
When a person is responsible,
He affords for his carries.

When a person is responsible,
He cares for his joy.
When a person is responsible,
He thinks life is as a toy.

A person can play,
Until he has hunger,
A person can play,
Until lightening has thunder.

A person can play,
Until climax suits to him,
A person can play,
Until he has a nice, trim.

A Person Can Trace

A person can trace a person he has such skills.
When he blames a person, he becomes a criminal.
Then why is he criminal and innocents suffering?
Then who will trust in it if he fights for covering?

Someone isn't guilty when he is breaking system,
Law cares for his safety and believes in custom.
Barriers and traditions a person is feeling tiredness,
What will be future if human has a guilty kiss?

He works for joy but conscious fills in pressure,
When he feels guilt and thinks himself in a crusher.
When he has strength, he never cares for his deeds,
When he feels sick and dies for his greeds.

Nobody has tracing greeds as he made him nervous,
He never understands always wanders in curves,
Crisis comes and he replaces it with cleverness,
But he is only a man who is a big robber.

He Feels

When a matter is understandable,
When a problem is discussionable.

When agreement is settleable,
Then job flexibility is much able.

Then why a worker is so crazy,
Then why he bends a job to rest lazy,

Output is nothing but he pretends to be busy,
A person can't afford, as he feels so easy.

If a person cares for him and his job,
Then benefit will be sure no need to rob,

When a person worries to survive for sob,
Then he is determined to fight against a mob.

You Can Gain

When son was young,
His father was old,
When his father was young,
His father was old.

They all were children,
They all were young,
They all were old,
Everyone has living a time gold.

Don't do that do only this,
This is for success that pests.
Everyone have a chance,
Get it do n't miss.
If you want to gain,
Why is your attention main?
Do n't create burden,
Only use other's brain.
Secure yourself and keep others busy,
It is a hard task it is not so easy.
You will be a good master,
If you are active, not lazy.

Five Marks

You can answer
If question is wrong,
If answer is right,
You can sing a song.

No need to think,
You need to do it quick,
You shall loose five marks,
If your brain is thick.

If you did it right,
You need a further fight,
If you did it wrong,
You need a back flight.

One plus one, why makes two,
One minus one it makes null too,
One multiplies one is also one?
One divides one also one is through.

Dear Wood

Does n't cry in the darkness?
If you should sleep in bearwood.

If you feel cold in the darkness,
You shall need for fire a clearwood.

If you feel sad in loneliness,
You have need to burn a cheerwood.

If you shall be afraid in darkness,
You have no need to burn a tearwood.

Don't care for anything in danger,
You need to fight in a fearwood.

Happiness is a game of two,
It will appear if they play in dearwood.

I am very lucky

I think, my landlord feels very lucky,
Always when he stands
Front of a big building,
He compares in his mind,
He is very lucky,

He has all luxuries,
Bank balance, big trade,
Heavy comfortable vehicles,
But I am only a labourer,
Always running to pay off bills.

Human nature complains to God.
Against his better serving.
When he pours rain, then we complain.
Never thinks he is provider, fresh food and air.
But my landlord always said, 'you are very lucky'.

He was good looking,
Nice attractive, lovely smile
And appealing performance,
Later I found, he is diabetic,
Also has blood pressure.

High cholesterol and angina,
A fear of heart attack has sustained,
He suddenly fell over and 'd stroke.
The big building and all luxuries,
Never strengthened him to enjoy them.

Before he died,
He went into comma,
Few months he was on dumb bed,
Body survived with machines.
But how long a man can support!

His wife died with kidney failure,
Son got a terrible shock,
He was admit in mental hospital,
All luxuries failed to become him normal.
Oh God, you are only better known.
You are my protector,
I am very lucky, indeed.

Burning Ashes

My body,
It starts to burn,
When someone,
It sparks on.

A fire breaks out,
The flames of anger,
Goes out of control,
Someone likes burning.

A Body cools down,
When a fire burns itself,
The burning ashes.
It cools down after a fire.

Fire that burns a belly,
To digest food,
To steam up pressure,
To maintain,
A body temperature.
A temperature for living.

When A Person

Dirt,
When a person breaths,
It comes into our mouth.

And a person,
It spits again,
But the Earth.

Where from,
It starts to travel again,
How is cool?

It seems very natural,
To come back home.
Sanctity is human fraud.

Nothing is pure,
Nothing is fresh,
But purification is only a process.

Air holds virus,
It transplants to every heart,
Every Brain without a distinction.

Zero

Zero,
A very bottom line,
Where from,
A person starts to walk,
Forward,
A person can go,
Backward.

If someone,
Walks forward,
he thinks,
he is very lucky.
If someone goes backward,
He thinks,
He is unlucky.

Zero,
It is only a place,
Where from,
A person can measure,
A success of his life,
A progress for prosperity.

Her Cry

When she saw a snake,
In her room she was cried out,
Someone came and catch him,
She felt safe and started to live safe.

When a person came in her life,
He was as beautiful as snake,
But his poison was hiding,
After his sweet chats.

First few months he loved her,
And made her a dream girl,
But suddenly, when he listened,
She has a pregnancy.

He bites her so badly,
She was only terrified,
She was not a patient,
But she was also not normal.

She was cycling in her dreams,
As a webworm,
That seems to her a coming forward,
To glut her for his appetite.
Why is fear only my life? She cries.

That who Deserves?

She was frightened,
When she heard,
He has another love affair,
Also, she has a child.

She has decided,
Not to see him again,
She thought, he is a cheater,
He isn't a good lover and a father.

When someone told her,
He is a good person,
She cried loudly and objected him,
Someone's goodness not proves,
He is a good father or a lover.

If a person is a good friend,
If a person is a good person,
Why is he not a good father?
Or a lover that he deserves?

Commitment of Love

A couple was sitting in the garden,
When a person saw a butterfly,
He ran after to catch him,
And thought to present her,
A natural beauty.

A couple when entered in the garden?
They smelled lovely flowers,
They touched their soft leaves,
A person plucked a flower,
To present her a natural beauty.

A couple when entered in the garden?
They saw Birds, they were playing,
And loving eachother,
He ran after a feather to present her,
That was his commitment of Love.

Listen To Others

Listen to others,
When they criticise you,
Listen to others,
When they advice you.

Don't ignore others,
When they hate you,
Don't spare others,
When they discriminate you.

Listen to others,
When they care for you,
Listen to others,
When they dare for you.

Don't listen to others,
When they are non-cooperative,
Don't cooperative others,
When they aren't supportive.

Listen to others,
When they have feelings for love,
Listen to others,
When they having a reward dove.

Don't listen to others,
When they have no expectations,
Don't listen to others,
When they lose appreciations.

Listen to others,
Your deed is a need,
Listen to others,
Freedom is good feed.

I Feel Unsafe

When I am abnormal,
I write poetry,
I have only a tool,
To satiate my crying soul.

When a person feels helpless,
He seeks someone's kind treatment,
So he can recover himself,
That's why encouragement is need.

Few people are lucky,
Someone that understands them,
Their shares provide them energy,
To knocked down a problem.

I am worry because I feel unsafe,
Although I am standing at the top,
My voice is reversing to me,
But after that forest is very calm.

I Heard Him

When a person was delivering,
Leaflets door to door,
When a person was calling them,
For a demonstration,

When a person was on strike,
They never supported him,
When a person stands for them,
And asks them for a voice,

When a person was delivering a lecture,
They never care for him,
They were always busy,
Domestic matters were only their need.

They never care for candidates
They never care to vote them,
They never care for campaigns,
Always they remark, politics is n't good.

When a flood made them homeless,
They opened their eyes and watched others,
They were waiting for their president,
They were asking what he would do for them.

Yes, I heard them when they said,
Politics and equal rights is our need,
A choice for a candidate is our need,
Society cannot develop without service.

At That Time

When a person is healthy,
When a person is wealthy,
When a person is intelligent,
When a person is experienced,

At that time, when he has no option,
Accept than cry, time realises its existence,
When a person has only feelings,
At that time when he feels himself a poor,

He feels about the members of a family,
He feels about his friends,
He feels about his relatives,
He feels about his relations,

At that time when he feels helpless,
He thinks he needs someone,
He feels he cannot walk without help,
At that time when he has no option,

He cries for help, when he feels danger,
He understands when crisis threats him,
Why is struggle necessary for humankind?
At that time when he wants to live.

A fight with empty Hands

Dedicated to:
India: BHUBANESWAR:
Barber women 'sexually abused,
Paraded naked' by upper Hindu community.
Saturday September 24 2005 00:00 IST

Why my soul wept out,
Why my soul has a cry,
I am waiting for that day,
When someone will realise my pain.

One hurricane touched your life
And one hurricane touched my life,
They have arrangements to resolve a matter,
But I am fighting with empty hands.

My Bind

Don't write so lengthy,
A person can't understand,
Don't write so hard,
A person needs a dictionary,
Please write so simple,
A person shall read it to think,
A person shall read it to smile.

Don't feel shame on my advice,
Please write if you want to read my heart,
Please write if you like to praise me,
Please write if you want to co-operate me,
Please write, if you want to share my pain,
Please write if you want to keep me happy,
Don't write if you feel I shall be annoyed.

I like to read to strengthen my mind,
I like to read to go forward not behind,
I like to read to learn a different kind,
I like to read to work hard for honest find,
I like to read to choose someone for my bind.

A Wallet

Last year in winter,
When he was ready for job,
For many days a little dog comes,
And scratches his door.

He goes out hurrily,
And went off without a notice.
But today morning, suddenly,
His feet were stopped.

Last night was a snowy night,
Snow has covered all low,
And high surfaces, the slopes,
Were dripping to make a noise.

He had seen a scrunch,
That was streaming under the snow,
He was surprised that dog was lying,
On a icy floor and the eyes were closed,

Quickly he picked him,
And put him front of a fire,
After an hour, he started breath normally,
When he went for out he also jumped back.

He scratched snow and picked a wallet,
The same that he lost few months ago,
And he blamed to his wife,
She was annoyed and left home.

I never thought you should come back,
When my mum hand me over your flowers,
I were delighted to inform you that,
You had your son last night.
It is a miracle, he shouted loudly.

That Plant

The high walls and a closed factory,
Everyday I acrossed,
When I went to town,
I were alone or with my family,
My eyes always touched its height,
And watched at that plant,
It was grown up in the wall.

Who has planted it?
And who is feeding it?
I have seen it has a big growth,
I also have seen flowers,
The white flowers and birds,
I have seen them playing together.
At the top, there was no disturbance.

The sun kissed him, every morning,
And evening, a shadow never touched it,
Rain bathed it naked,
Strong winds never harmed it.
I never seen afraid around it,
When a person is naked,
He never afraids and cracks system.

As the top grew, plant has strong roots,
Everybody has seen these cracks on wall,
Few months later, the big wall,
It was damaged and falls down.
When a poor is naked,
He feels shame on him, the poverty
Roots are as strong as a top grew plant.

A Fired Jungle

Early in the Morning,
When I check news,
I spend my day to understand,
Why is nature so cruel?

Why did disasters again and again?
Why is humanity suffering?
Is human failed to keep his trust?
Why is he delivering punishment?

The innocent's cries always,
Chased me and disturbed my peace,
 Is human has so ugly face?
Innocent tears and empty hands
That shaken my body.

I amn't responsible for all.
But I can't run I also feel hunger and thirst,
Their unwashed face has a cry,
Is there anyone who can hear us?

I don't know why my conscious is alive.
Why is it pointing at me always?
I feel one day I shall be burnt alive,
I feel I am standing in a fired jungle.

Son of Devil

If academic degree is sufficient,
To mobilise or to activate,
To improve a vision of someone's nature,
To learn skills and to provide,
Best opportunity to deliver,
A better service for the welfare,
And for a high standard for living,
I also succeed to get a higher degree.

When I found myself,
Degree develops only sources for living,
Not sufficient to establish,
Justice, Equality, Liberty and fraternity,
I had lost a balance of my life.
I stop to read only books on a subject,
I chose all the basics that I need,
To become a human: a civil person.

The society is facing injustice,
Inequality, bonded labour, racism,
Prejudicism, what is behind them?
Only degree holders,
If they were human and civil person.
Nobody cries on Earth for help,
Poverty, injustice, racism,
Inequality and racism,
Is a provision of these intellects?

If they are educated,
Their standard should be based on education,
As they have belief,
And service, it seems,
There academic education is bluff.
Who does prepare children for suicides?
Who does care soldiers to kill innocents?
Who is greedy and not selfish?

Was Lord Jesus academic?
Was Lord Mohamed academic?
Was Lord Rama academic?
Was Lord Krishna academic?
Why these academic people still have belief,
Heaven is better place for living,
They are dishonest and corrupt,
They deliver cruelity and exploitation,
Because they are son of Devil.

Why are only?

To UN gathering in New York, 2005.
(This Poem is dedicated to Dalit human rights
Caste violence: Wednesday, August 31, 2005 (Gohana):
60 Dalit houses burnt down in Gohana, Haryana, India.)

Do you know why matters are pending?
Is nobody has interest to touch them?
Actually, a person deals with a matter,
Why does he need it for a benefit?

Who cares about justice?
Thousands files are hiding cases,
They demand to proceed for justice,
Are the concerned people not aware it?

Terrorism is high spotted agenda today,
Poor Dalits are suffering over the centuries,
Their human rights and a terrorising class,
Is still a hiding case as benefit seekers deal?

Are they made options only for Muslims?
They feel their activities are terrorising,
But when they shall feel about Hindu terrorists,
Who burns Dalits houses and rapes them.

Today world's unanimously adopting,
Why is it on terrorism only for Muslims?
Who shall speak for Dalit human rights?
Why is world blind for Hindu terrorists?

The Fact of Living

Earth, Moon, Sun, Mars
Or any other planets,
Have a same visit?
They share only a sky.

Everyone has his gravity,
A small one is cycling
After another a big one,
Also that has circling.

Everyone has a neutral space,
Nobody disturbs others,
If unluckily dies someone,
The black hole gluts it.

The black hole has responsibility,
As Rain clears atmosphere,
To clean up the sky,
Who controls them?

Is he a master of techniques?
Is he a master of wisdom?
Is he a master of planning?
Can someone beat him?

It is as parallel as a human is,
He cycles in his circle,
Also he has circling,
A small is circling,
After another a big one,
What's a fact?

Will They Awaken?

When a person is criminal,
He adopts his professionalism,
He thinks, a Judge or a Justice,
They are law.

Before a service of Law,
He has a best try,
To paralysed a system,
Where his recommendations,

Or his power of money,
Or his Relations,
Always are superior,
Than a consciousness of honesty,

Where a Judge or Justice,
And their subordinatives bodies,
Will admit that a criminal,
Has no commitment of Crime.

All the allegations are wrong,
The system of Judiciary,
The Police, defenders, witnesses,
Are a totally rubbish?

The belief will be challenged,
Openly in a day light,
The corrupted soul will be honoured,
The cause of his office,

Who can survive a Justice?
Where God will be ashamed,
With these dared handed.
Who can survive innocents?
Will another terrorist have birth?
Who will challenge?
Why responsible person are corrupt,
Will they awaken?

Why is Law?

Law,
A power adopting consent,
Unanimously,
For the welfare of all,

To establish equality,
To provide opportunities,
To remove discrimination,
To break down the prejudice barriers,

To build a bridge on gaps,
So anyone a child, young,
Old, able or disable can walk,
Freely, with honour of a nation,

And can adopt a pride of safety,
And can provide security,
It is a lesson for everyone,
To protect society,

From Criminals, robbers,
Smugglers, gangsters, rapists,
For everyone's share of happiness.
For a standard for living.

A Ready Fighter

He was healthy,
But he was noisy,
He was feeble,
But he was quiet.

When he feels,
Someone's fiddles,
It demonstrates against him,
Happiness comes to ashamed someone.

Although few of them,
They blame him an abuser,
And called him a ready fighter,
But he feels pride on his struggle.

He always argues on them,
They feed as pigeon to shut their eyes,
But never realised why a Poacher,
Hiding himself behind a net.

He advices a person should n't be so soft,
He will die for prayer and admit,
God shall come to teach him a lesson,
It is everyone's need to stand for justice.

Image of Freedom

Freedom,
Totally a different vision,
Where a person dreams,
Only enjoyment,
Without anyone's consent,
Without anyone's interruption.

How can we define?

What is human nature and how can we define?
Human nature is adorable and understandable.
Human nature is actionable and appreciable.
Human nature is appraisable and affectable.

Human nature is affable and affectionable.
Human nature is admissible and admireable.
Human nature is approachable and affordable.
Human nature is achievable and adjustable.

Human nature is believable and blameable.
Human nature is breakable and sustainable.
Human nature is courageable and capable.
Human nature is correctable and changeable.

Human nature is criticisable and compatible,
Human nature is corruptible and comparable.
Human nature is careable and curable.
Human nature is comfortable and collapsible.

Human nature is credible and creditable.
Human nature is debateable and demonstrable.
Human nature is dreamable and digestible.
Human nature is detectable and dyeable.

Human nature is discernible and discerptible.
Human nature is delightable and creatable.
Human nature is eligible and forcible
Human nature is flexible and fallible.

Human nature is functionable and freightenable
Human nature is fashionable and enjoyable.
Human nature is gullible and greedable.
Human nature is honourable and habitable.

Human nature is heartable and hopeable.
Human nature is irritable and incredible.
Human nature is indelible and irascible.
Human nature is invisible and irresistible.

Human nature is incorrigible and imaginable.
Human nature is irresponsible and loveable.
Human nature is legible and liable.
Human nature is likeable and mistakable.
Human nature is memorable and amusable.
Human nature is negligible and navigable.
Human nature is noticeable and negotiable.
Human nature is ostensible and originable.

Human nature is perceptible and plausible.
Human nature is predictable and peaceable.
Human nature is presentable and questionable.
Human nature is quotable and responsible.

Human nature is reliable and definable.
Human nature is readable and reproducible.
Human nature is retainable and recognisable.
Human nature is rememberable and sensible.
Human nature is supportable and suppressible.
Human nature is surpriseable and suspectable.
Human nature is tangible and tillable
Human nature is thinkable and terrible.

Human nature is tryable and trustable.
Human nature is tolerable and unstoppable.
Human nature is vulnerable and acquirable.
Human nature is liveable and smileable.

He Thinks

He thinks always,
One day will come,
When he will be dependent.

He will cook and eat,
As much as he loves drink,
When he will be independent.

He will walk and talk,
Where he will like to travel,
When he will be not adolescent.

He will fight and bite
As long as he will choose someone,
When he will be not innocent.

He dreams always future,
When he will be a man,
He will be intelligent.

He will care and dare,
When he will earn to afford her,
He will be polite and sufficient.

He will be honest and best,
When he will be hard worker,
He will pay attention and rent.

He will be a friend and father,
When he will prefer to live together,
He will be totally different.

Dying To Touch

She never thought why I have wanted to be a good man.
I want to do a better so I can prove I am her lovely fan.
She never thought: she has rejection of my nature,
I love her because I want to improve my future.

What are her nature, what and how she liked to do?
I work to find out my life wants to get through.
It is a matter of heart that he likes and rejects,
It is a matter of eyes that they rejects and selects.

If I am annoyed when someone goes to tease her,
If I am waiting for her when she goes a little far.
Few things happen suddenly I am trying to understand,
What human has different why he likes a special brand?

Something is missing from us that we have a fight.
We are learning to decide who is wrong and right.
Waves are coming and dying to touch a shore,
She likes cooperate but what is in your lore?

For My Fun

I like your figure when you went to swim.
I like your figure when you have a nice trim.
I like your figure when you play a game.
I like your smile when you feel shame.

I like your approach when you offer me something,
I like to keep hand when you walk in a shopping ring.
I like you when you ask me to arrange a trip,
I like to keep you in my arms you have a sudden slip.

I don't like you when you ignore me in a party,
I don't like you when you stop to talk after a party.
I don't like you when you ignore me to go out,
I don't like you when I came and you having a shout.

You can share if something is in your mind.
You can ask if somebody is working behind.
You can mange yourself if I am not good one,
I shall support you if your life is only for my fun.

Write a New Page

Where you were last night and why were you there?
Why do you do that, are you not stopping my care?
You can go anywhere if you have no personal matter,
If you have personal matter before to go, you need share.

You are a family person this is your responsibility,
If I mind and objecting to do, don't feel, you are guilty.
I am securing your time and providing a good support,
If you have spare time, you can read something and write,

Why do you think you are only wants to enjoy time?
Why do you ignore me always what did I have crime?
If you have job for money I serve you for my honour,
Respect is a common matter you will understand it sooner.

I am n't objecting only you have right to grow your skill,
I am asking only to share that's a gap I ask to fill,
Relationship is a base of trust, try to upgrade image,
I like to read you: please try to write a new page.

Object in My Phrase

She never realised the depth of my heart.
Until I didn't offer my wishes as a chart.
As long as she enjoyed my taste of kind,
She developed my gesturing in her find.

Days and nights, a winter and summer,
She was passing it away as a dreamer,
Everyday she builds a dream to lock herself,
She fights to enjoy it with automatic self.

She expects nobody will come to interrupt,
Until her needs doesn't offer her a joy gift.
She thinks to take bath in a cheerful pond,
She has her aim and objectives of a life bond.

She explains as sun grows and never delays,
She likes glamour as sunshine grows and displays.
I like to play, as I am young, heat is my subject,
I chose very carefully that nobody could reject.

I like to play with fire; I love to fly in smoke,
I like to fly in air where nobody using a break,
My feelings and thoughts charged me always,
Enjoyment is my aim love is object in my phrase.

Evening Waves

Mountain was leaving breath,
Grass and leaves were waving him.
Animals were grazing in the field,
Birds were playing in joy,
Cheerful Sun was hiding itself,
Behind the mountain's height.

The river was burning,
Golden flames were smoking,
Evening waves were jumping blue,
A silver bird was floating,
Air was roaring,
Eardrum was protecting a noise.

Ladies were going back home,
Piles of hay stacks was on the top,
The grass branches were hanging down,
As curly hairs was grazing beauty,
A baby girl was chasing her mum,
As fear was growing in dark.

Milky Shades

Sun was above the Head,
Heat waves were crossing,
Bodies smelt, but
Sweat was designing,
The skin was feeling cool.

Trees were very calm,
They were standing in dark,
But birds were singing,
Playing and dancing, and
Leaves were laughing on them.

Mostly roads were clear,
Very rear vehicle acrosses,
And a waving tune,
Touches the ears,
Road was melting on tyre prints.

Sky was clear, very often,
True cirrus clouds,
Still were playing, and
Rays were lighting,
On their milky shades.
He Will Comeback

Early in the morning,
When Sun's pregnancy,
Nearly was on delivery,
The cool wind was touching,

Hearts and body was shivering,
When thunder threatened clouds,
Diving and travelling in the air,
All were seemed in a race.

Birds were saying good-bye,
But baby bird's mouths were open.
And eyes are amazingly stirring,
And watching at waving feathers,

Fresh leaves were covered,
When Sun baby open his eyes,
Fresh leaves wept in joy,
And kissed earth,

With their golden tears,
Everyone is leaving home,
Time's belly was growing,
But hope was still in wait,
He will comeback home.
Evening will be cheerful,
Darkness will grow,
To cover all happiness.

Someone's Time

What is your conversation about?
Is it about education?
Is it about training?
Or you are talking only for time pass.

Is it n't our duty to confirm?
Before to waste someone's time,
Is a person willing to talk?
Or a person is feeling harassment.

Are you seeking an advice?
Or do you mind to consult someone?
Is it n't a progressive approach?
To investigate about a concerned subject.

So a person can reach to a useful link,
Before a dealing with any personality,
Is it n't better to save our time?
If we shall share only the key points.

A frugal talk can create suspicion,
Although you didn't mind to talk,
But few of them have their reserve nature,
But a talk helps to develop our relations.

A good conversation always helps us,
A person can remove over tension,
If a person enjoys talk for entertainment,
He is willing to talk or not, he needs to talk.

A person is living in a society,
He needs to learn for other's welfare,
Sometimes a frugal talk becomes useful,
When a person needs to resolve a matter.

Over Spends

A Day after day,
Every minute and a second,
A person is getting old.
A month after month,
A year after year,
Everything is getting old.
Not only human or animal,
Trees, birds, planets and nature,
Everyone is dying a moment.
Energy and time,
Also system generator power,
Loosing its grip.

Human progress is on natural resources,
A man has a fight for them,
Everyone wants to spend,
A luxury life without efforts,
But enjoyment is n't free as he thinks.
A man needs to think about over spends,
About his needs before to supply them,
Is he using for a necessary purpose?
For a good cause,
He needs to stop wasting,
If he is wandering to waste fuel.
A user's control can control prices.

A Pattern of Wisdom

A person is a child,
If he behaves as a child,
A person is mature,
If he behaves as a wild.

A person is kind,
When his heart is mild,
A person is selfish,
When only benefits he compiled.

A person is honest,
His treatment is fair,
He respects others,
And he believes to care.

A person is rude,
When he is dishonest,
He exploits others,
When he takes rest.

A person is loyal,
When his need is a matter,
A person is critic,
When he can serve better.

A Living Treatment

A person is short
Or a person is tall,
It counts,
How they treat,
When they bad fall.

A person is slim,
Or a person is fat,
It counts,
How they behave,
When they chat.

A person is old,
Or a person is young,
It counts,
How they entertain,
When they sing.

A person is black,
Or a person is white,
It counts,
When they understand,
They cooperate or bite.

A person is physical disable,
Or a person is healthy,
It counts,
How they manage to deal,
If it doesn't count,
They are poor or wealthy.
But it counts everywhere.

Penniless Dreams

Your News was very hot,
I were very excited,
You was coming to me.
But
The message was very cool,
When I heard,
You are facing insult,
And your husband,
Also beaten you up.
I were remembering,
My loving days,
When I chased you,
Every moment,
In a day light
and
Also in my dreams,
My life was blocked somewhere,
Where you was only my destiny.
I still remembering,
When you said me,
Love is n't only enough,
Money also has a matter,
Enjoyment has a meaning,
That is impossible,
If someone is penniless.
I don't want to hurt you,
You already have penniness bed,
That is firing around you,
But I like to confirm you,
I still have only love,
I welcome you,
If you like to live with my Love.

A New Subject

One way,
Where your duty was,
To advice someone,
Where you felt,
A person is wrong.

But
On other way,
Where a person was a receiver,
He thought that,
You are overriding him,
He didn't admit,
His mistake can be altered,
But his argument was that,
Why did you interrupt him?

He felt,
You have disturbed his peace,
He is complaining
To protect his freedom.
Your responsibility can mark,
Where a person admits,
Education means Learning.
Every moment is a new subject,
That he can learn through.

The Burning Fire

Flames
When touched,
Flames,
Body stretched,
And embraced,
The burning Fire,
And cooled down,
When few drop,
Lost their existence,
And Mind,
Enjoyed a long sleep,
When opening Eyes,
Matched their glance,
Again,
Lips were smiling on them.
Where a fresh morning,
The curtains were removed,
The Light was glimmering,
And
The Cold things feel warmth.

My Desires

Waterfalls as hailstone,
Droplets are tossed,
As pearls,
Build up layers of ice,
Sun was drilling the Rays,
Rainbow made a circle,
As a team of dancers,
Dancing on a stage,
And colours,
Matched attractive image,
Attraction was obliged,
Excitement were dreaming,
As Steam was vaporising,
Into the palm of Earth.
As A decorating face,
The snow queen,
Beautiful and very evil.
As my desires.

My heart always felt pain. If your heart also feels pain you never come to blame me. I adopt pain as I were thinking, learning is a new chapter for me but these folder never ends until my last breath. What is this education that never got progressive skills and I never become so sufficient to understand my problems? I never got a full belly of food to eat or enough sufficient fresh water to drink. I can sleep under the open sky. I never afraid of rain, heat or cold. If I afraid that was the pain of my belly, my body was burning in my appetite. I failed to learn. Is that pain natural or sophisticated? Daljit Khankhana